# Mandalas : Coloring Book for Adult

*Alina Maya*

# Coloring Book Designs for Stress Relief and Relax

*Copyright: Published in the United States by Alina Maya*

*Published September 2016*

*All rights reserved. No part of this publication may be reproduced, stored in retrieval system, copied in any form or by any means, electronic, mechanical, photocopying, recording or otherwise transmitted without written permission from the publisher. Please do not participate in or encourage piracy of this material in any way. You must not circulate this book in any format. Alina Maya does not control or direct users' actions and is not responsible for the information or content shared, harm and/or actions of the book readers.*

**ISBN-13 : 978-1537615097**

**ISBN-10 : 1537615092**

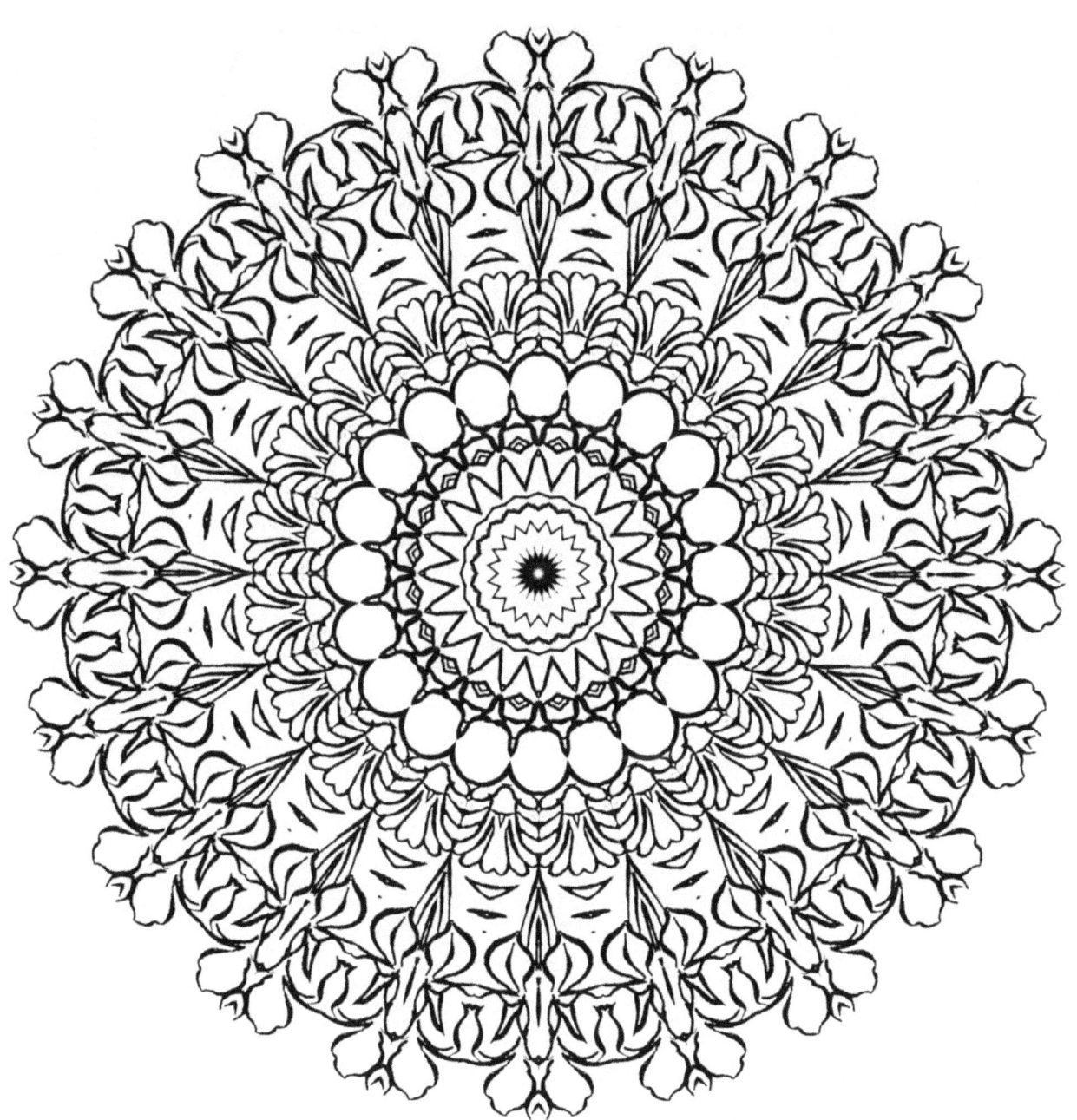

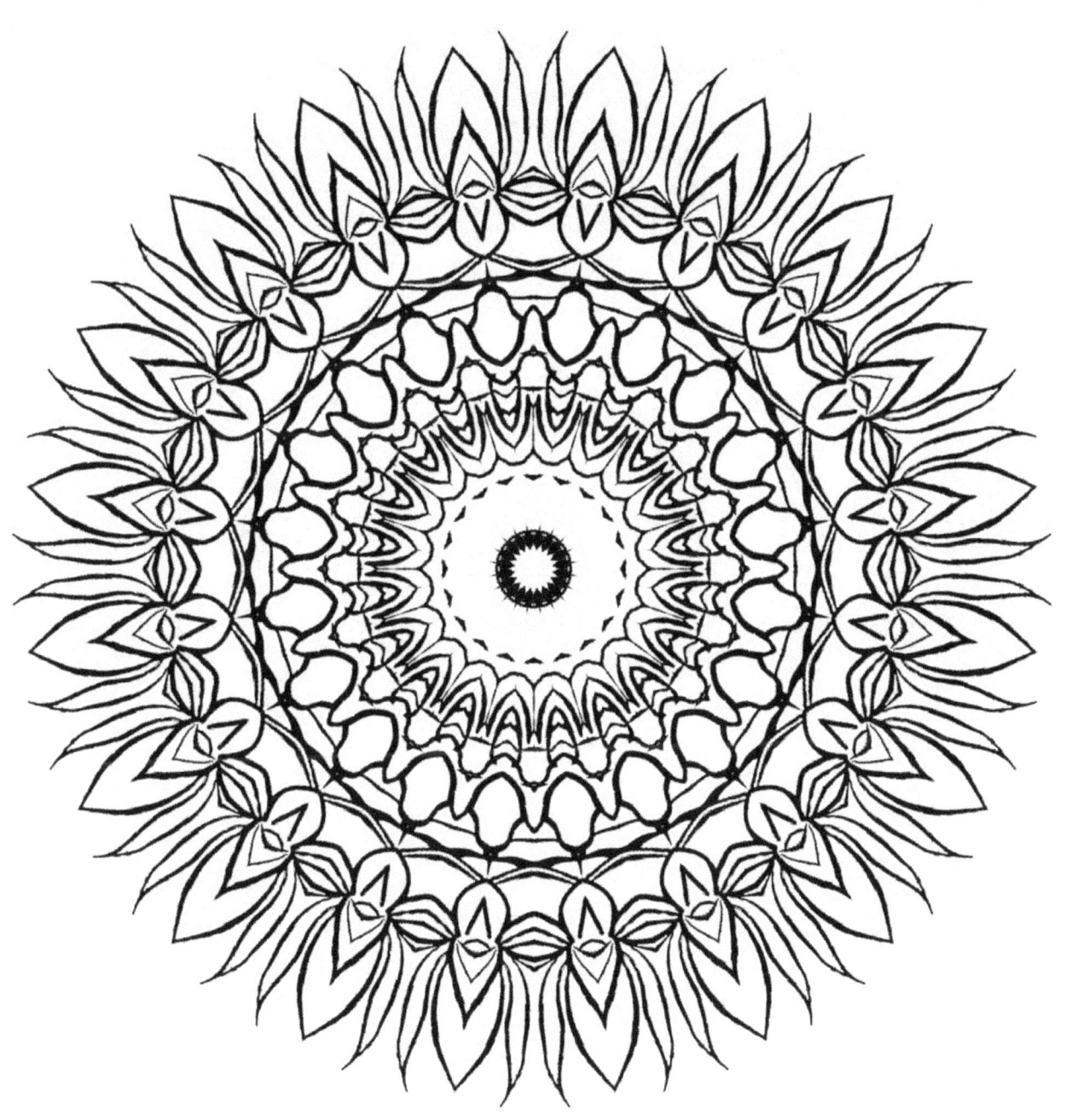

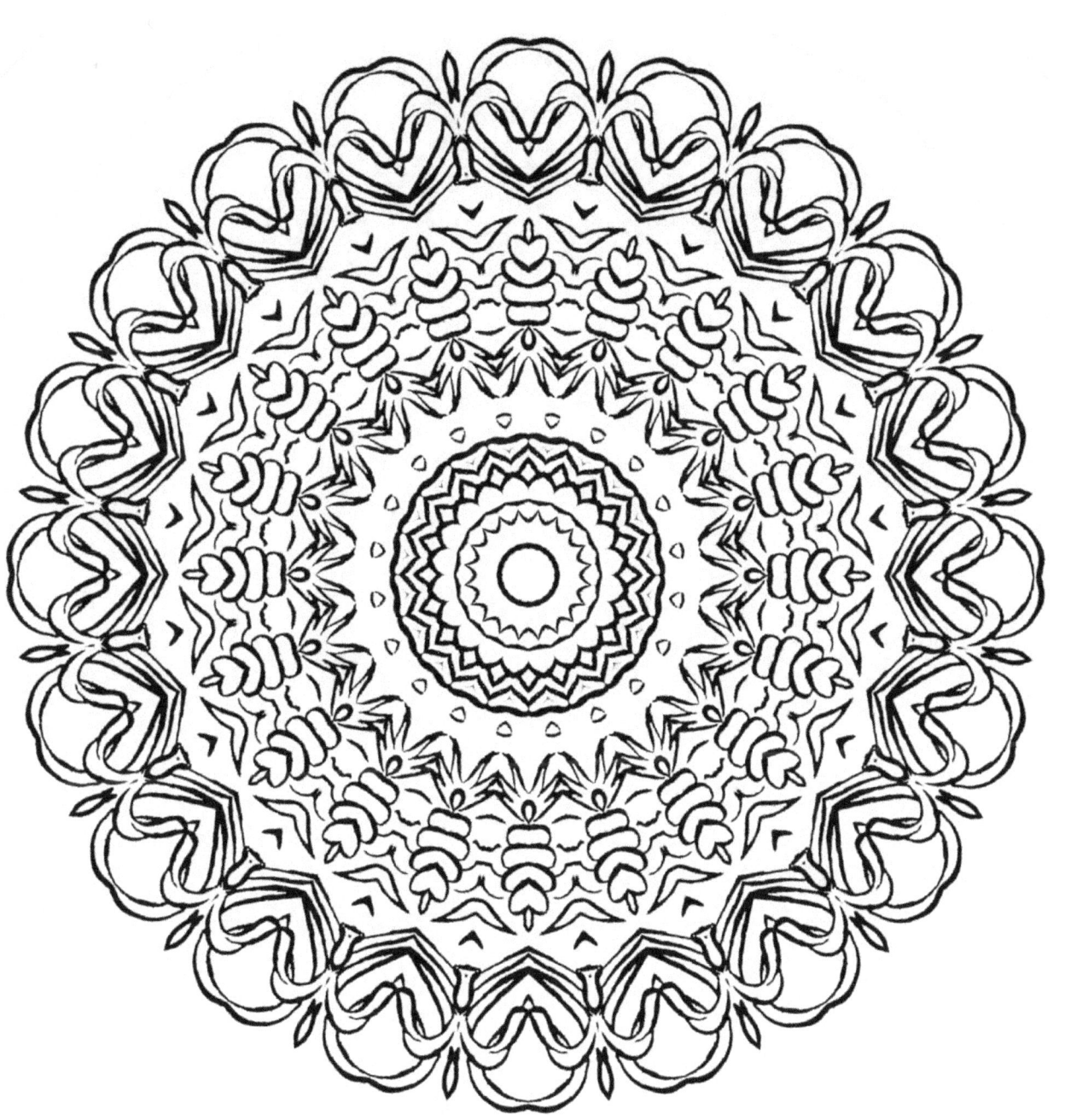

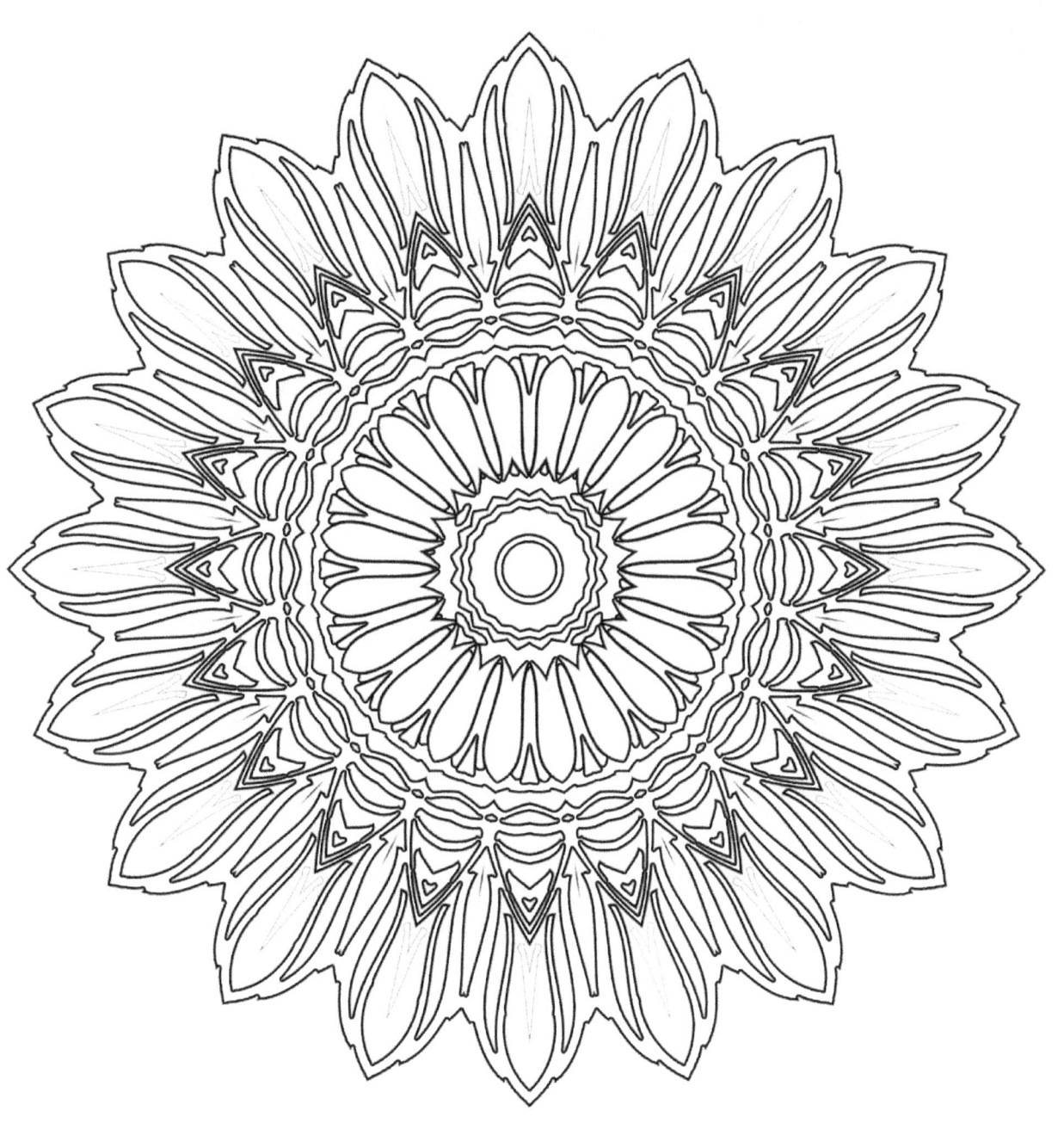

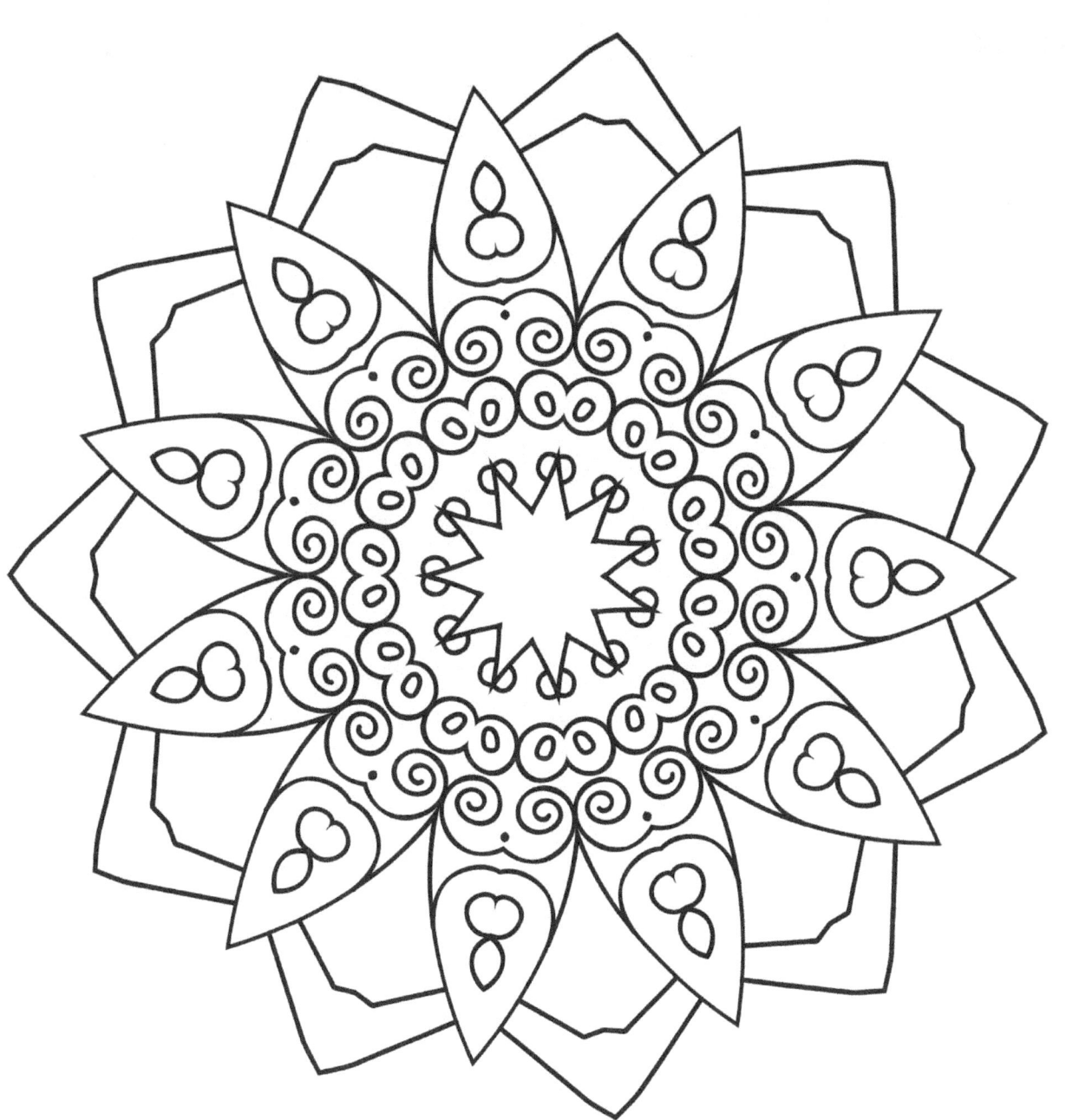

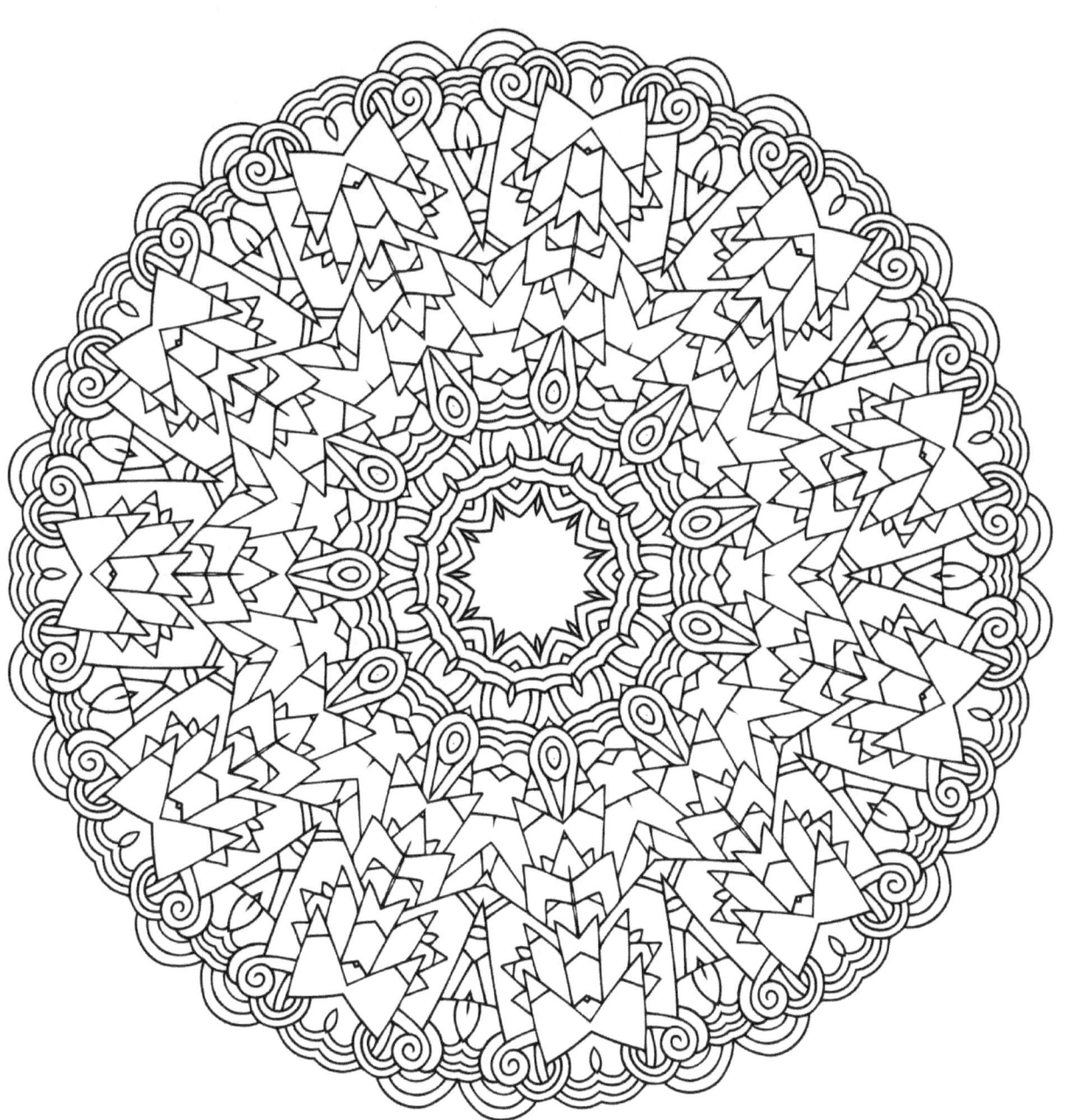

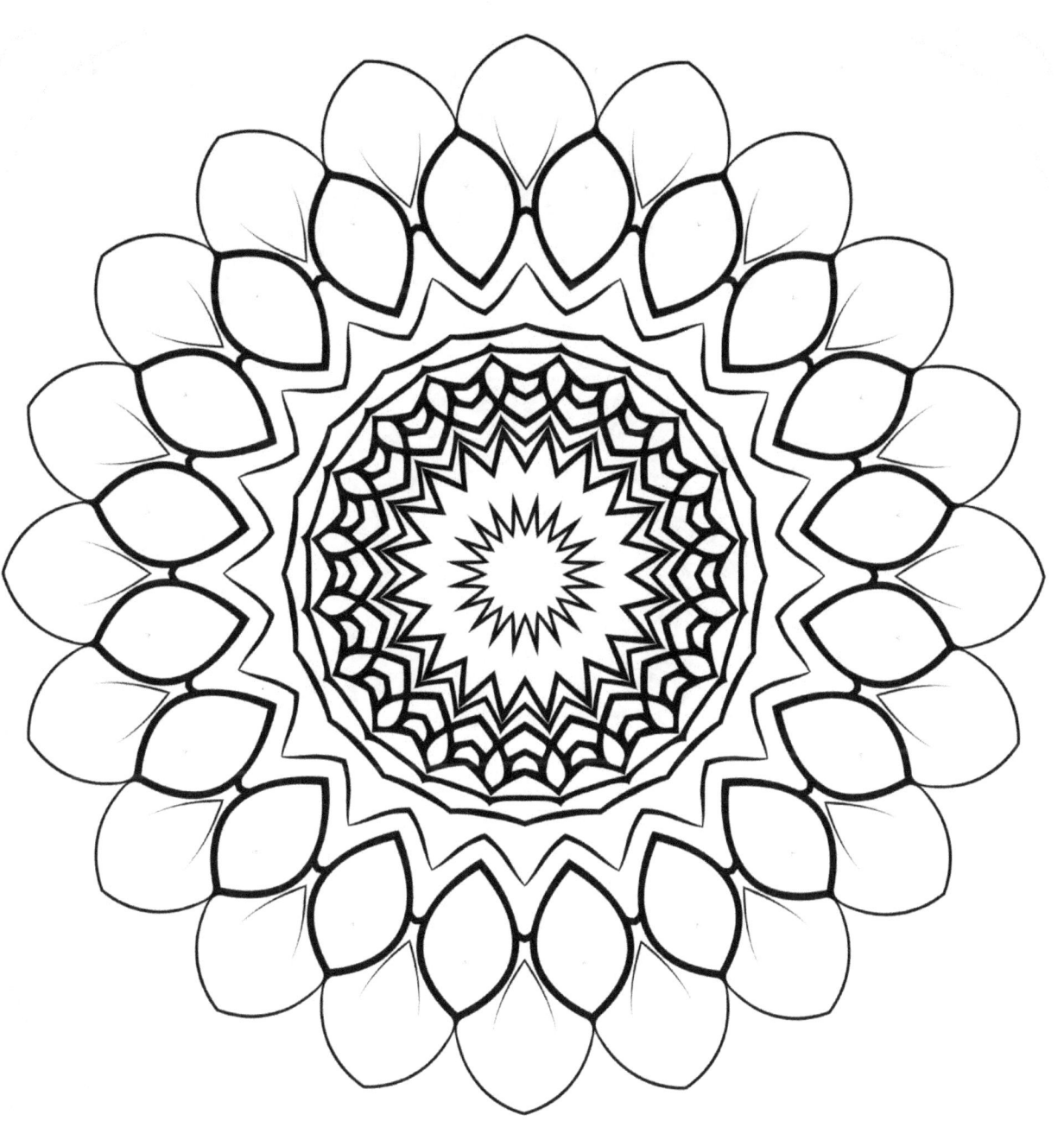

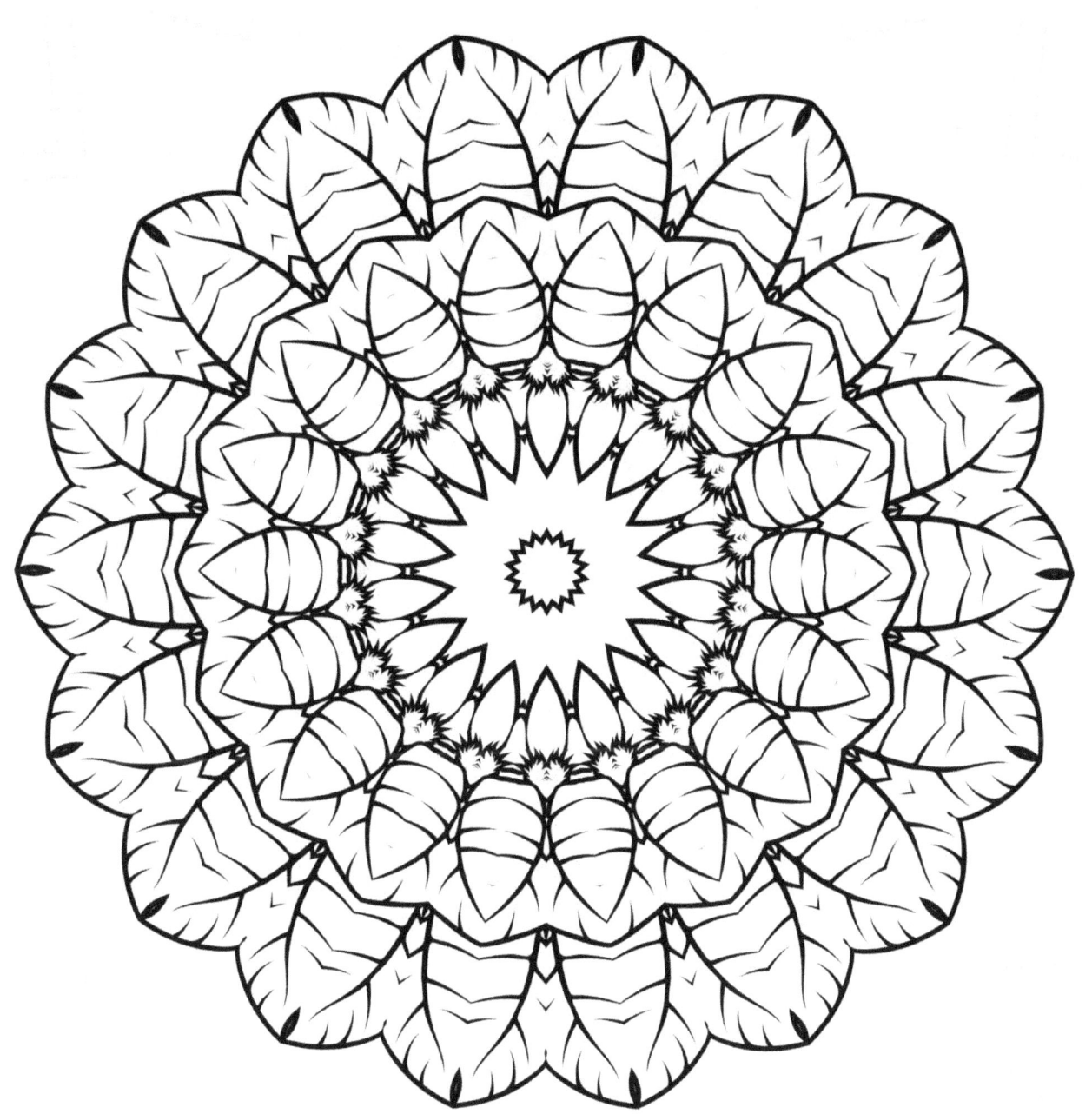

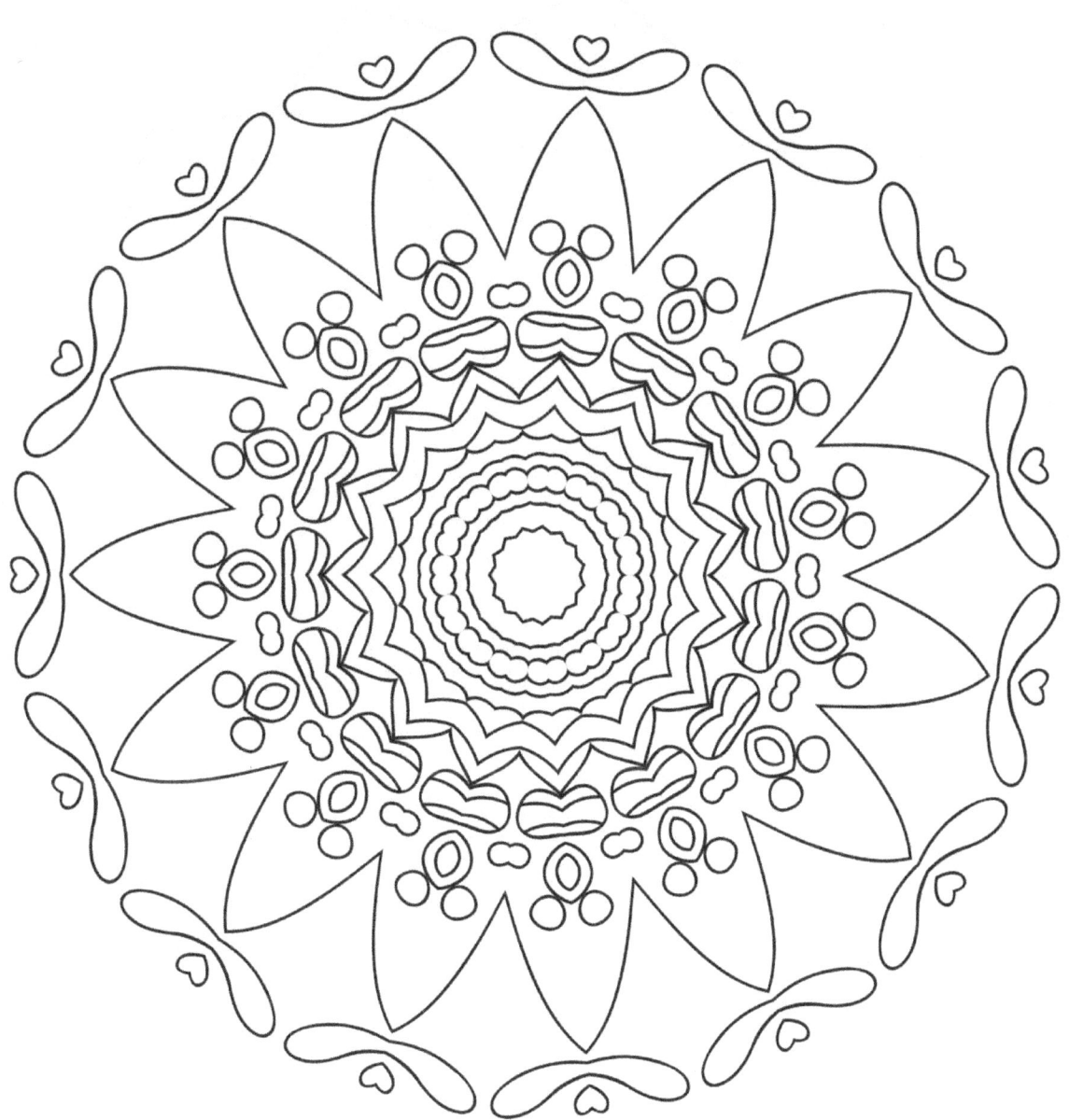

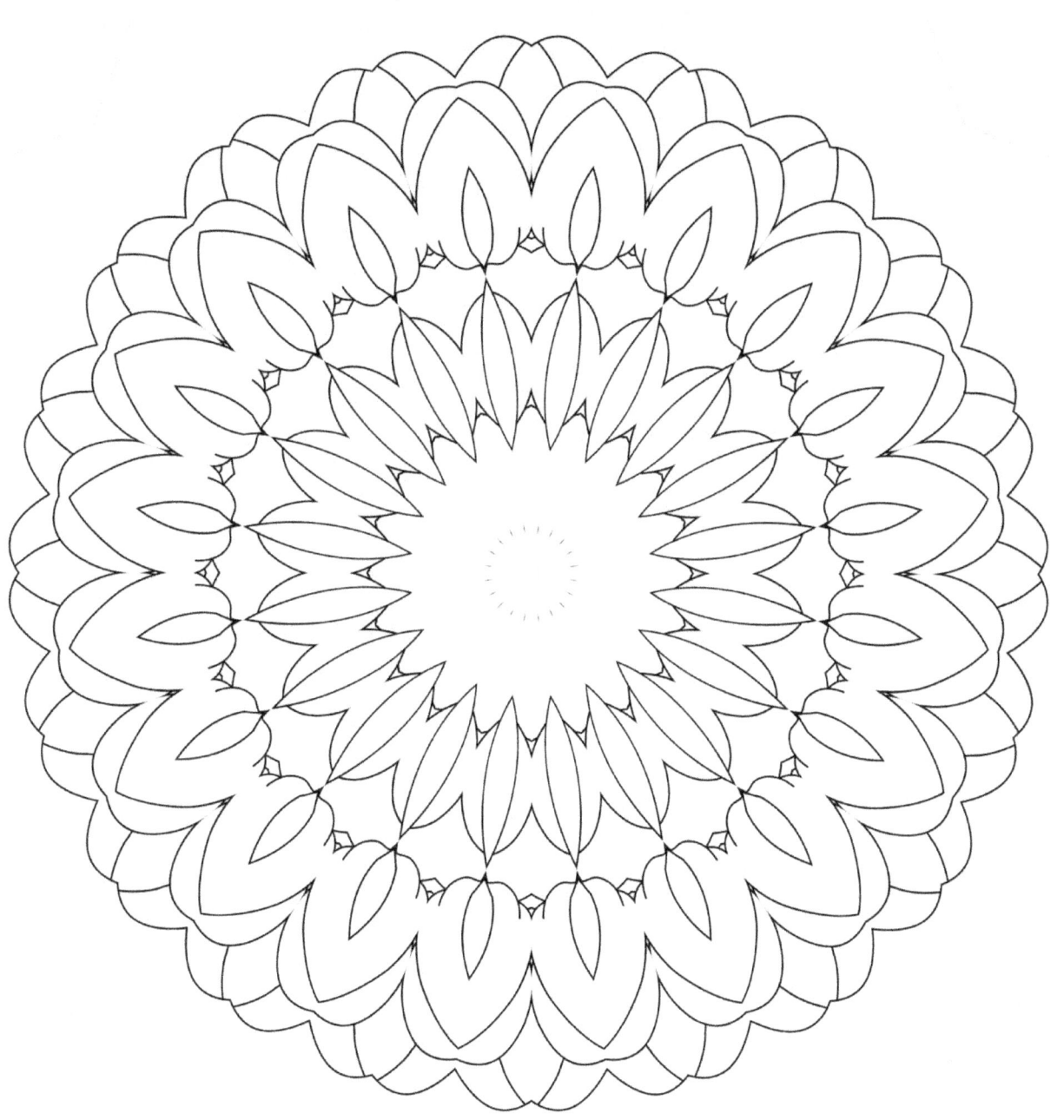

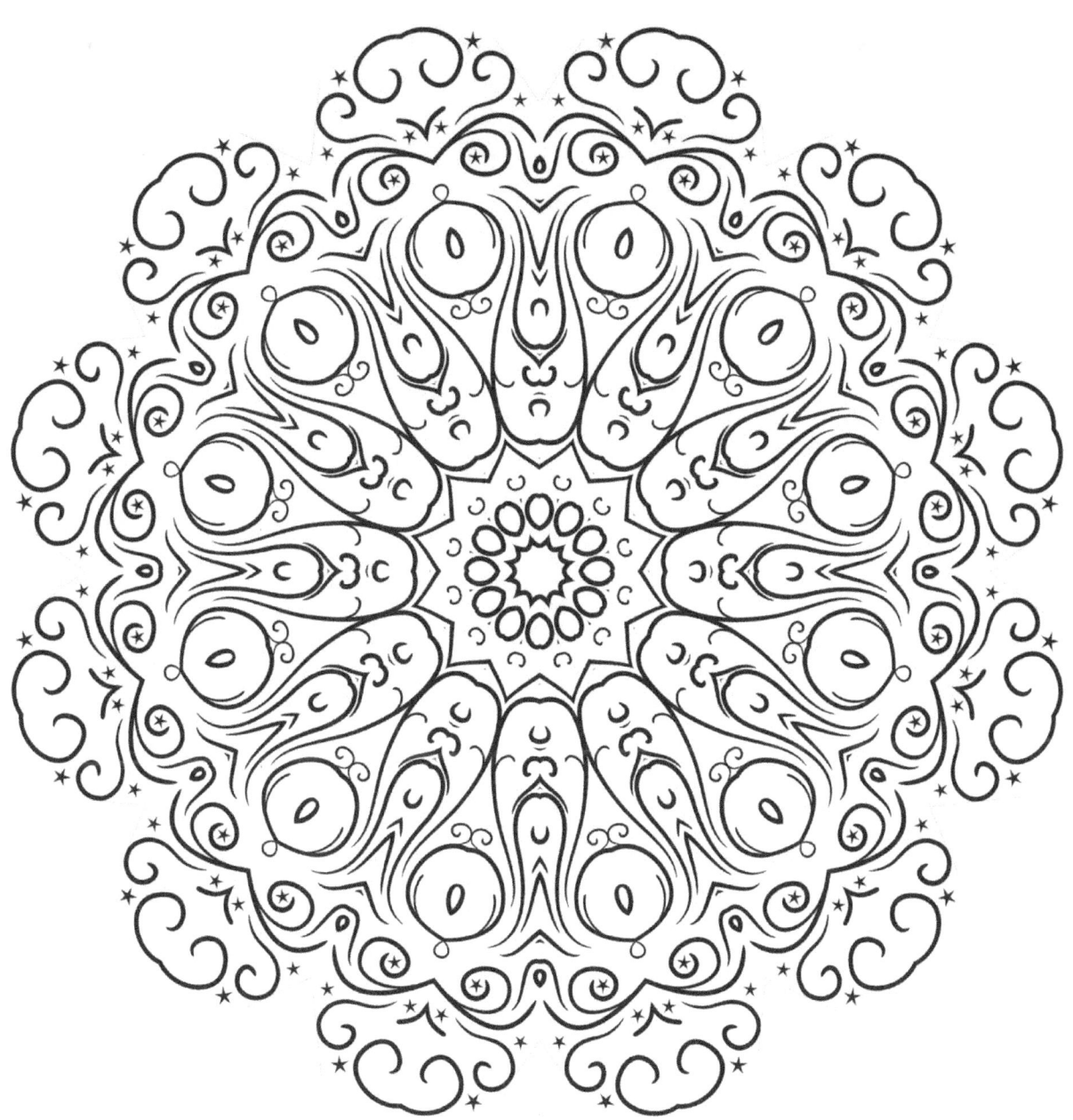

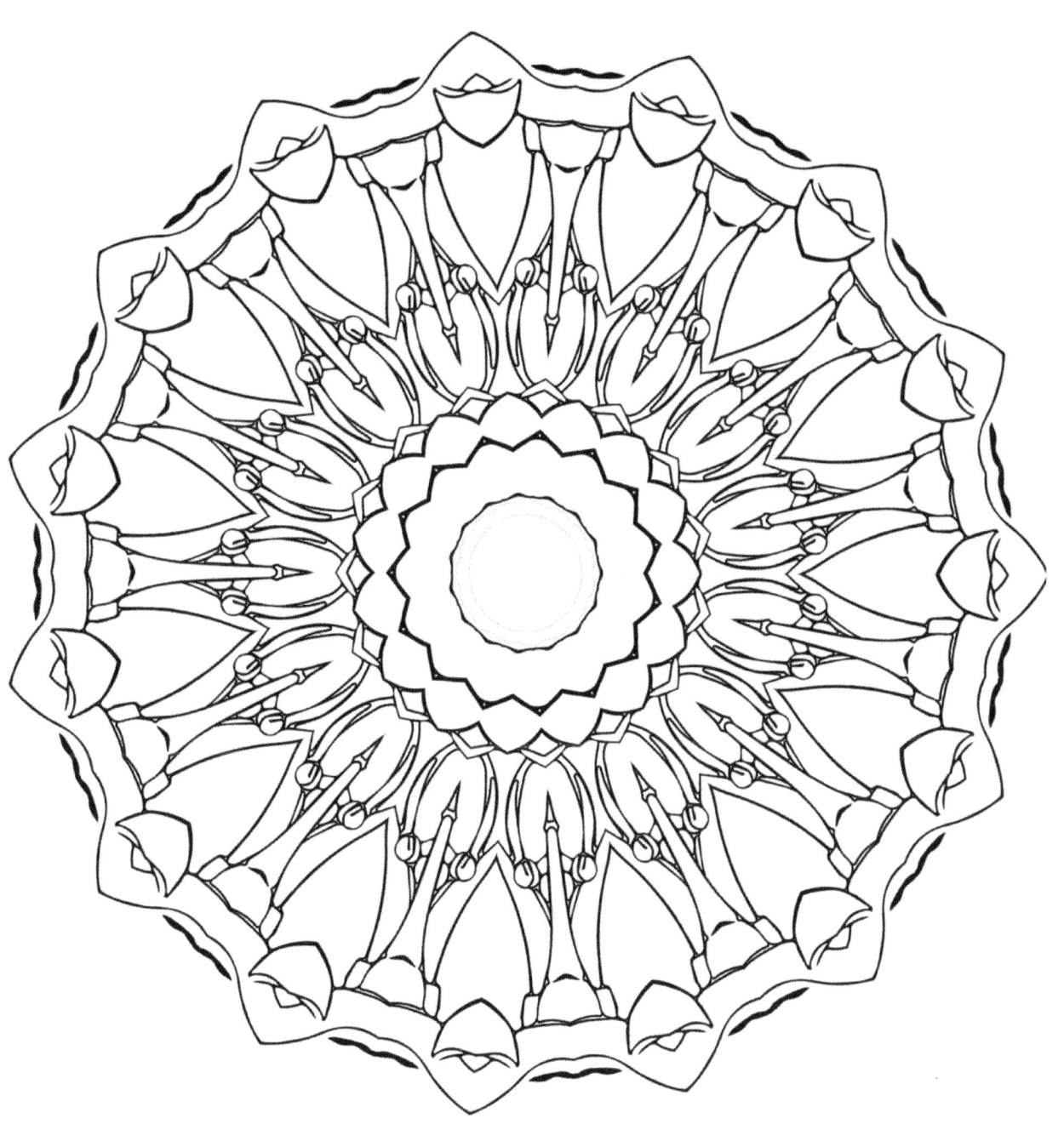

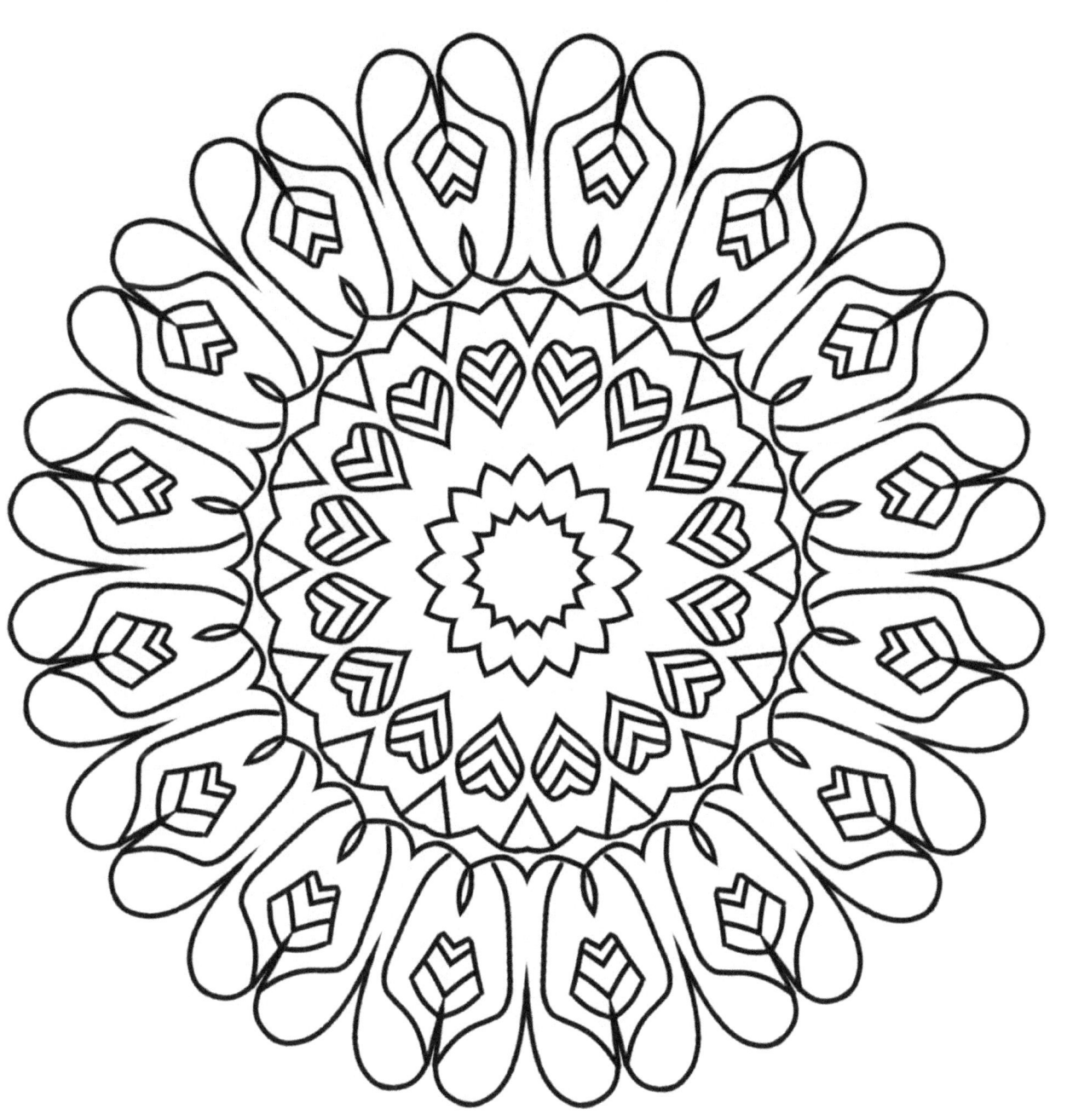

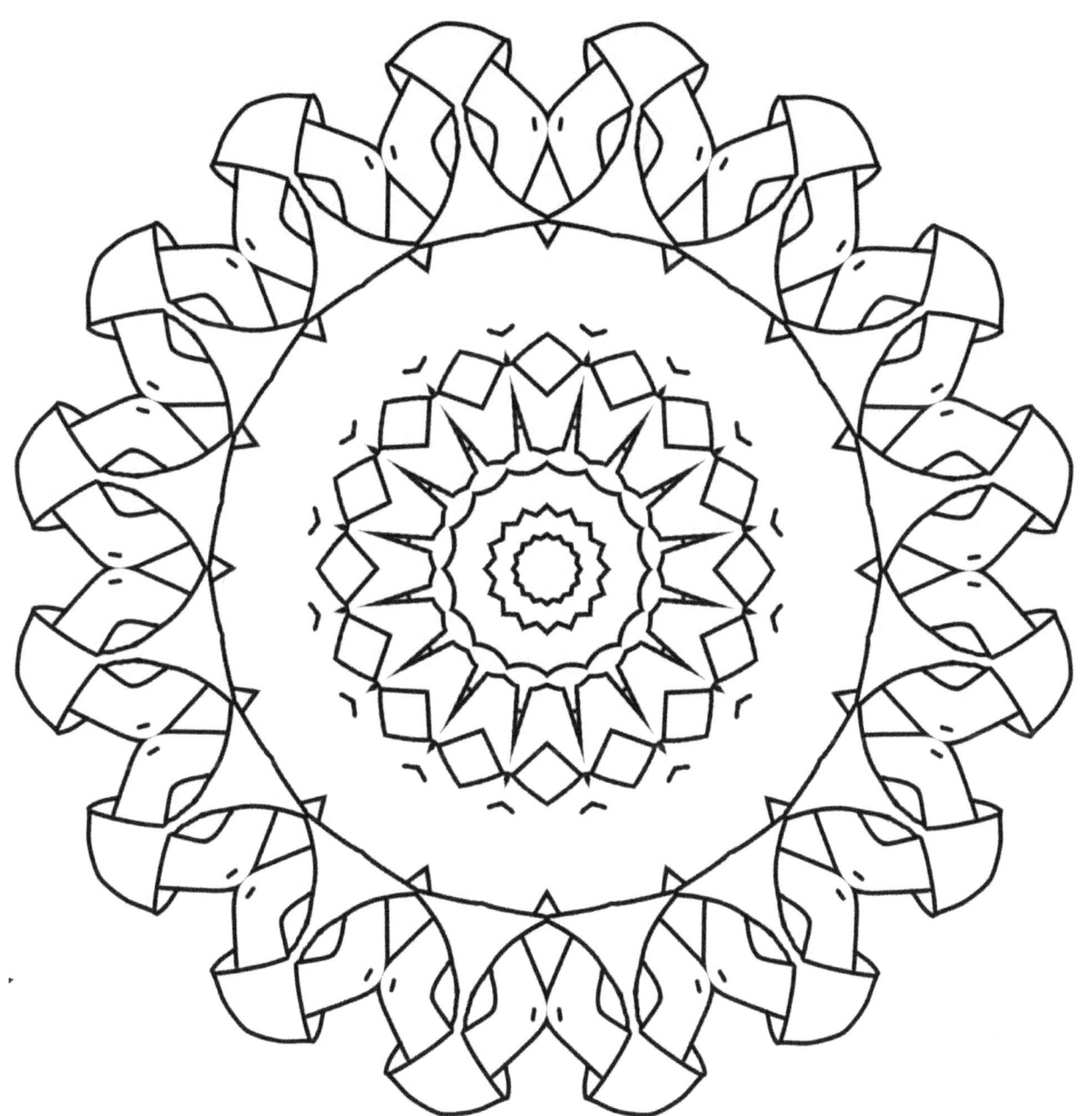

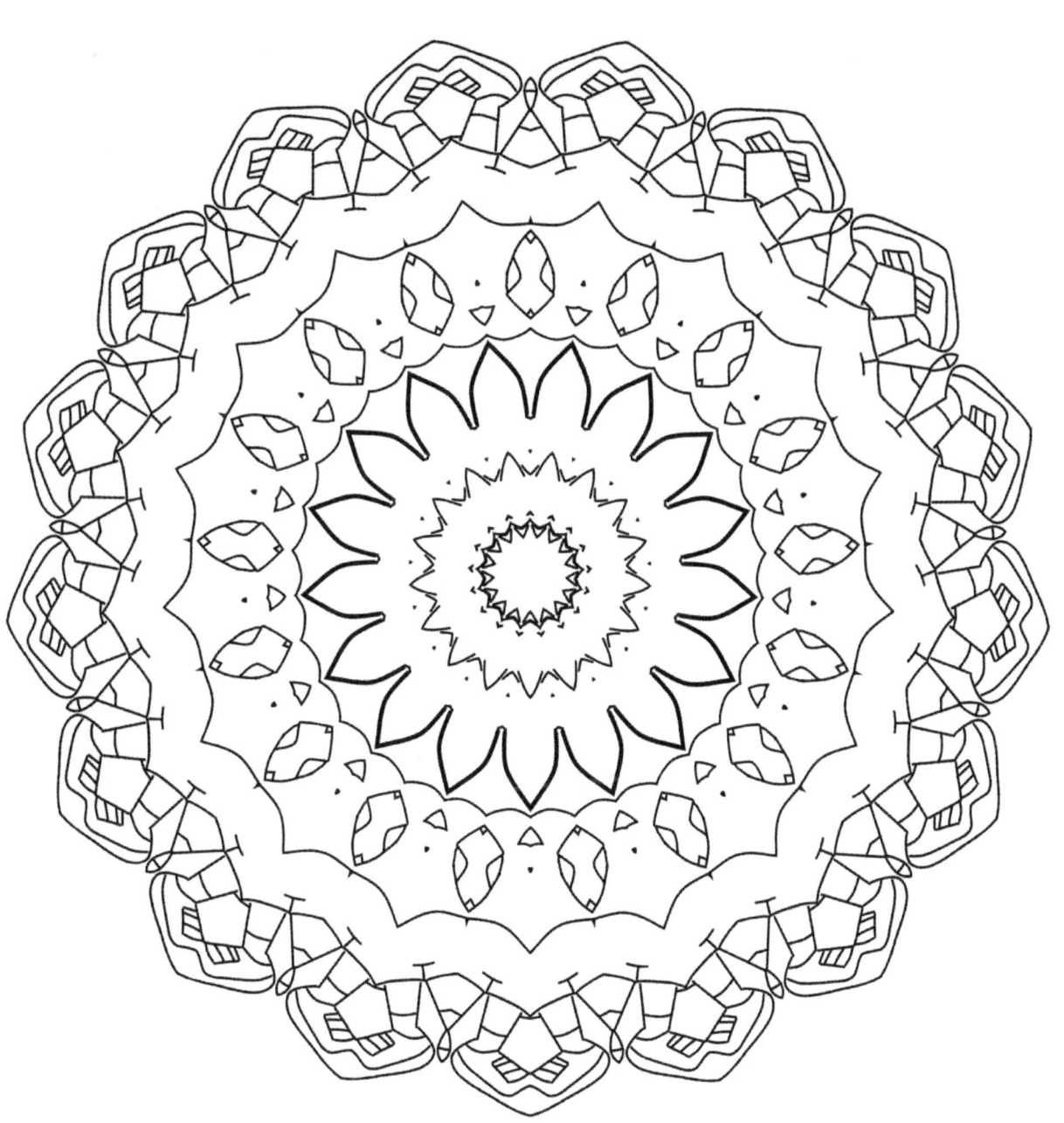

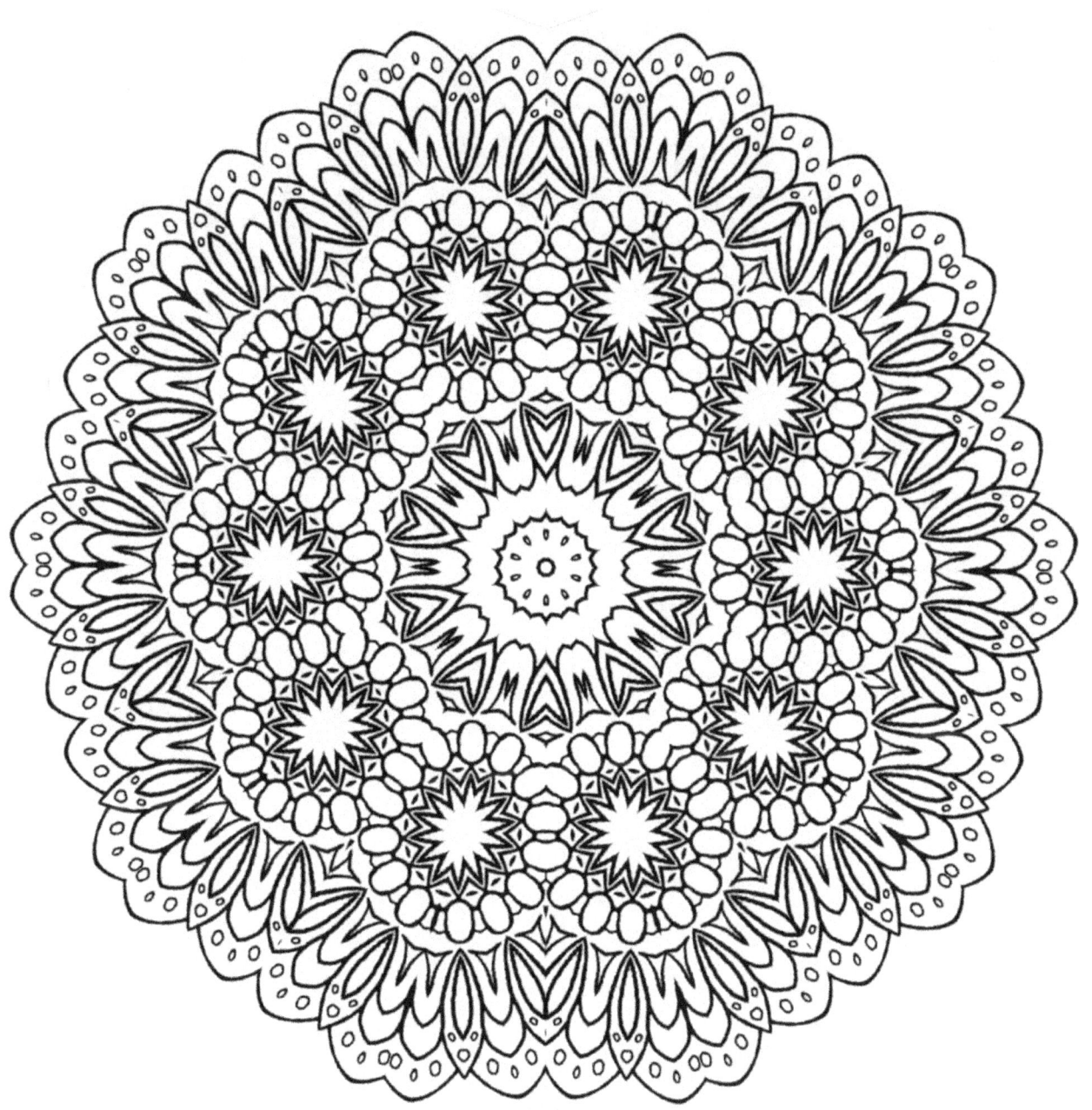

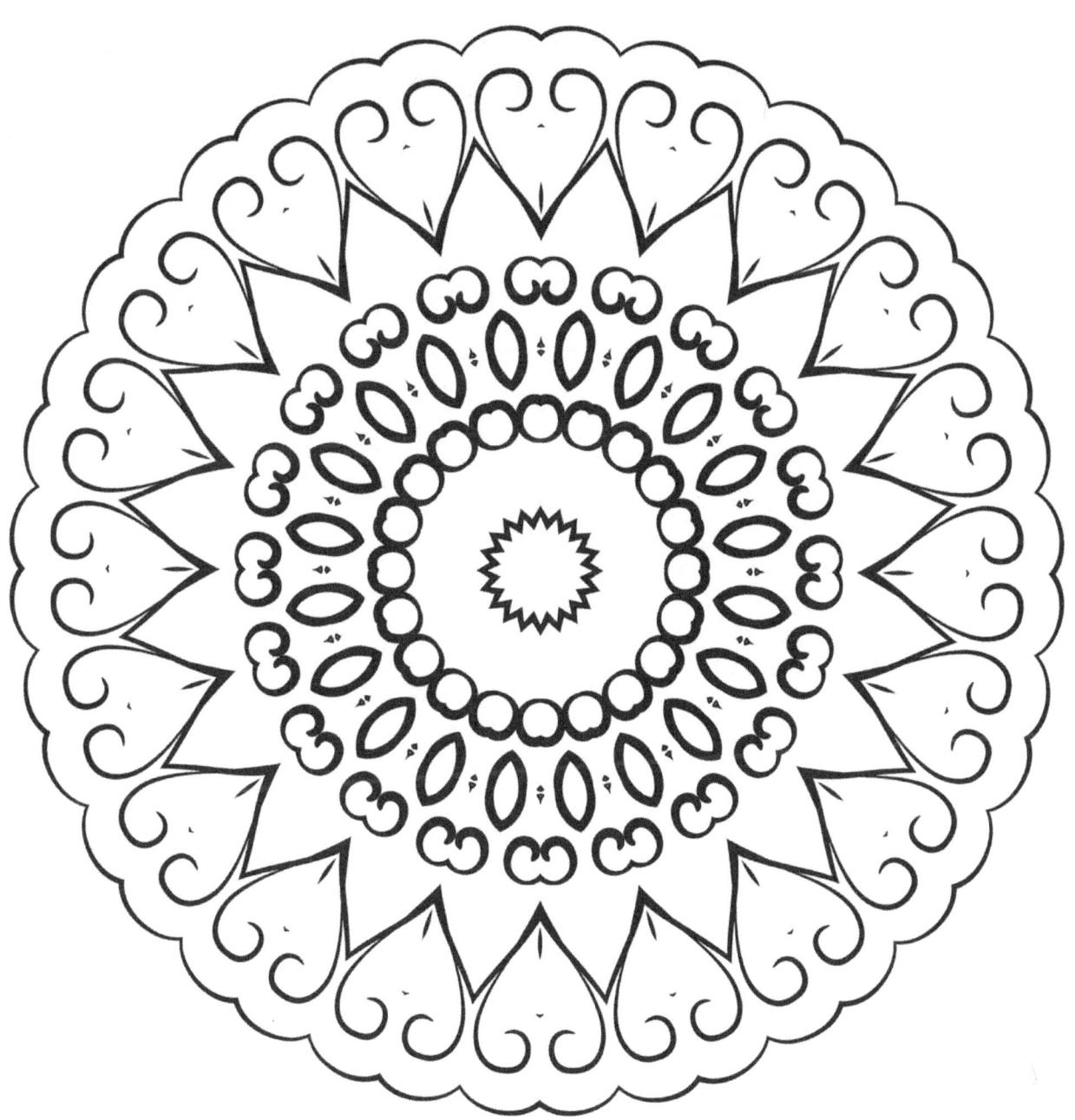

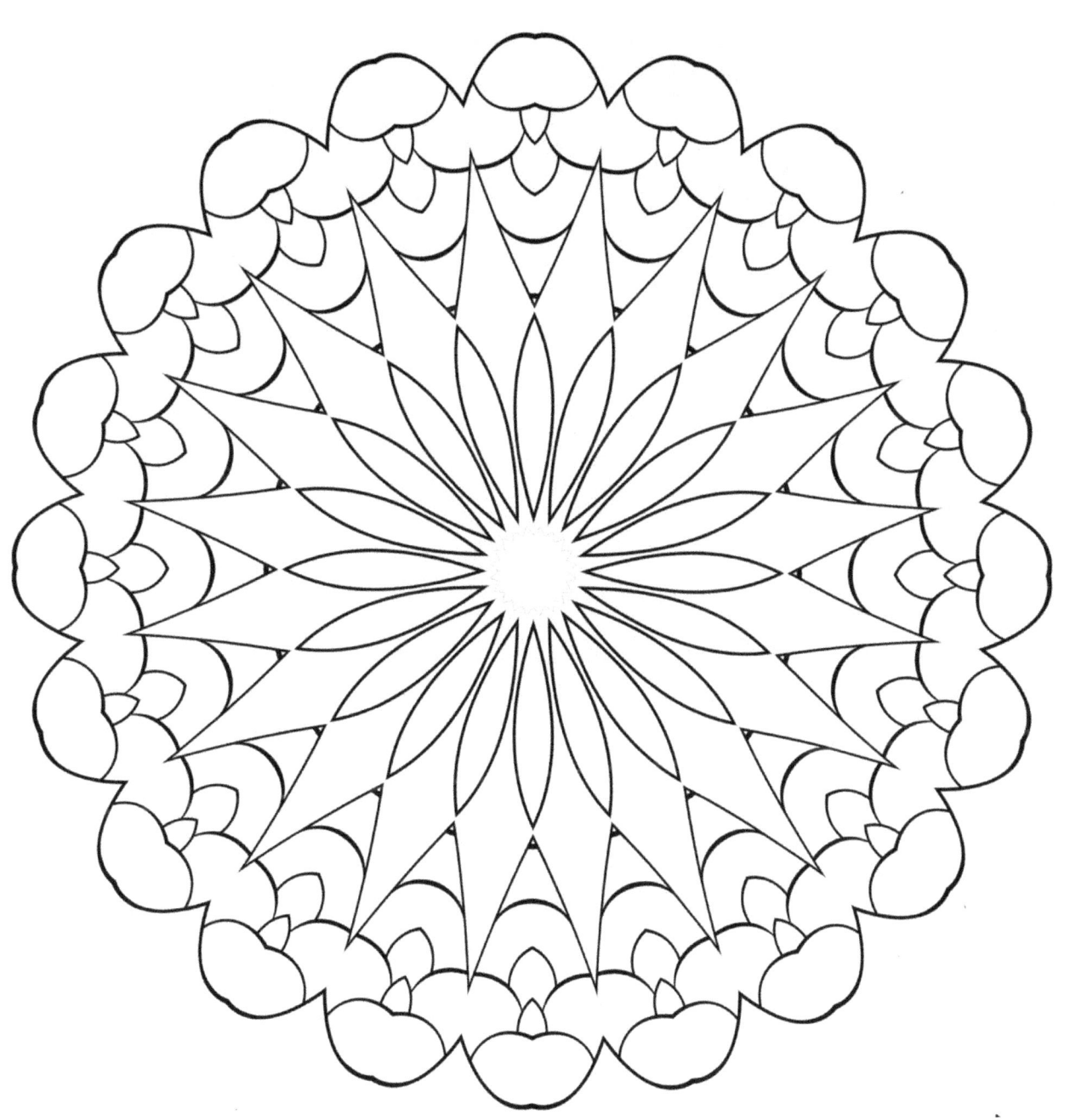

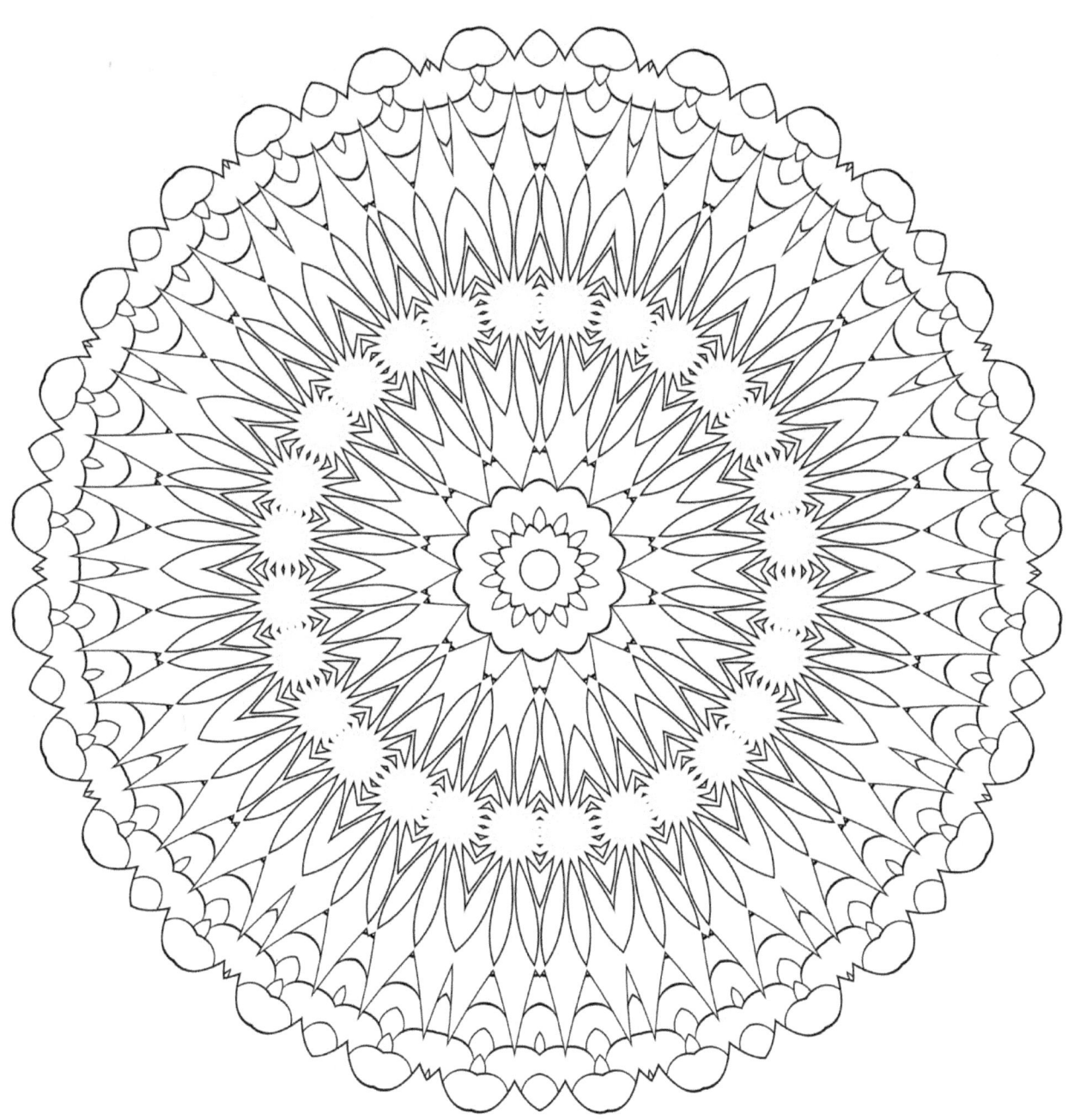

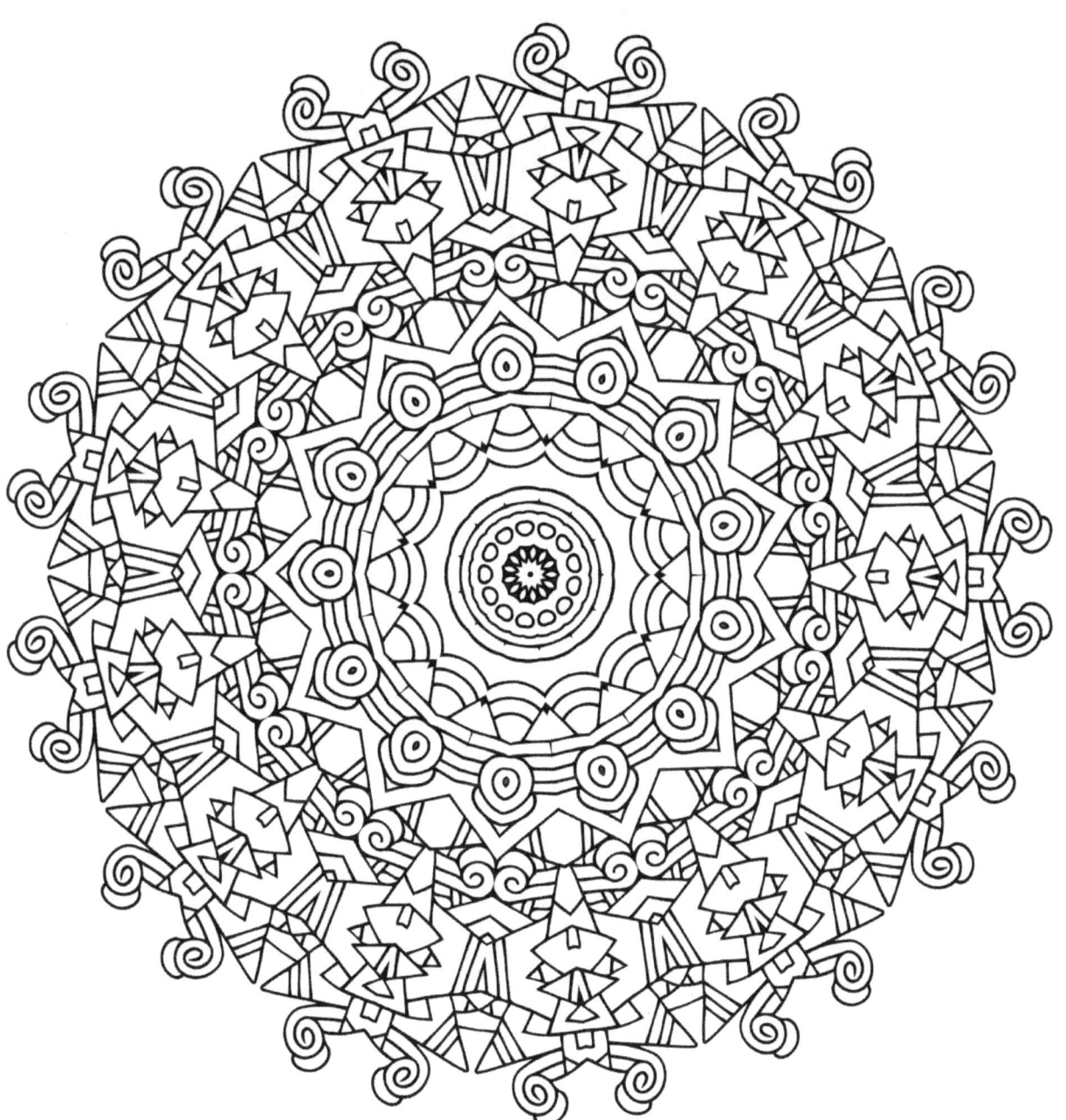

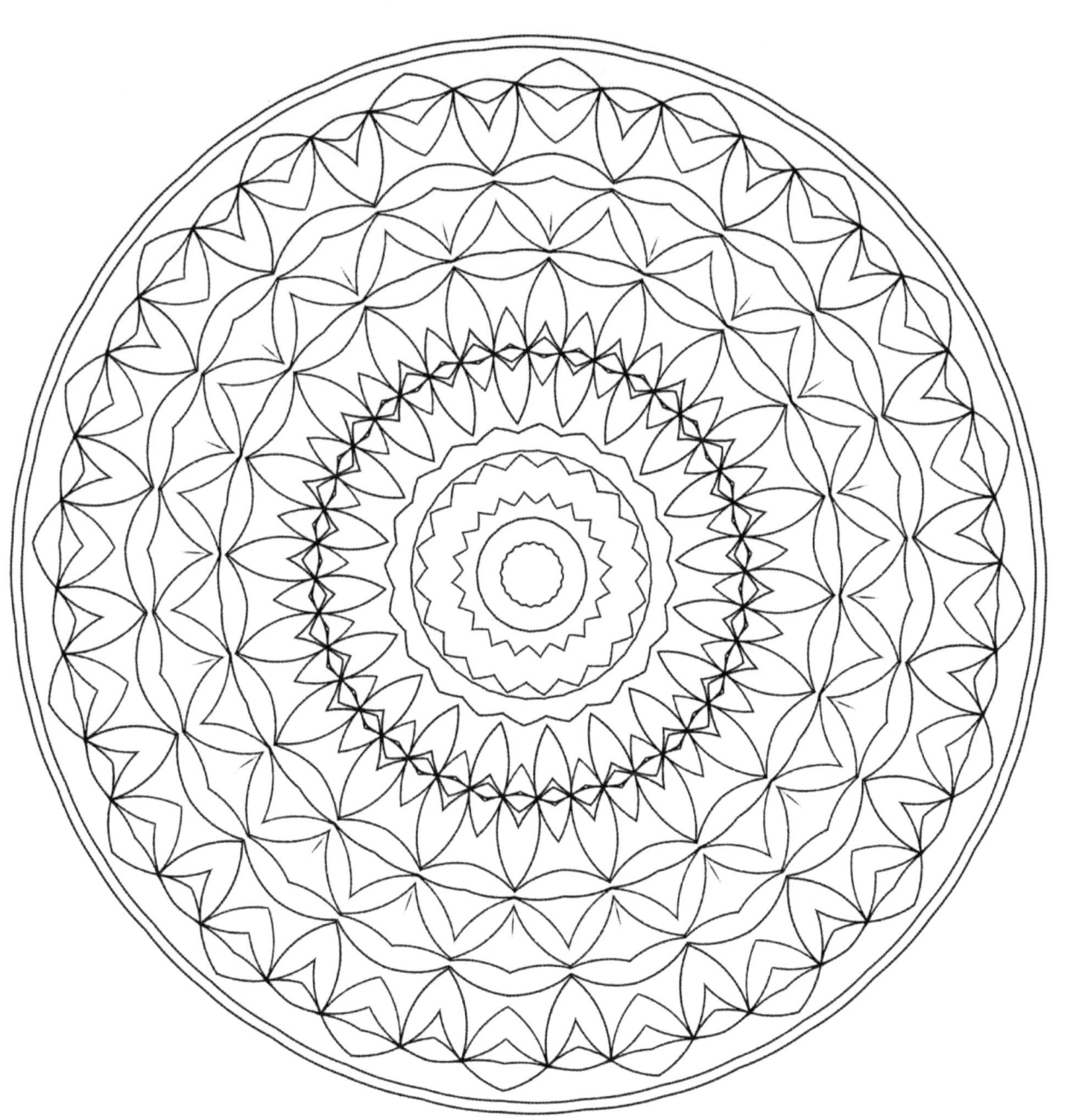

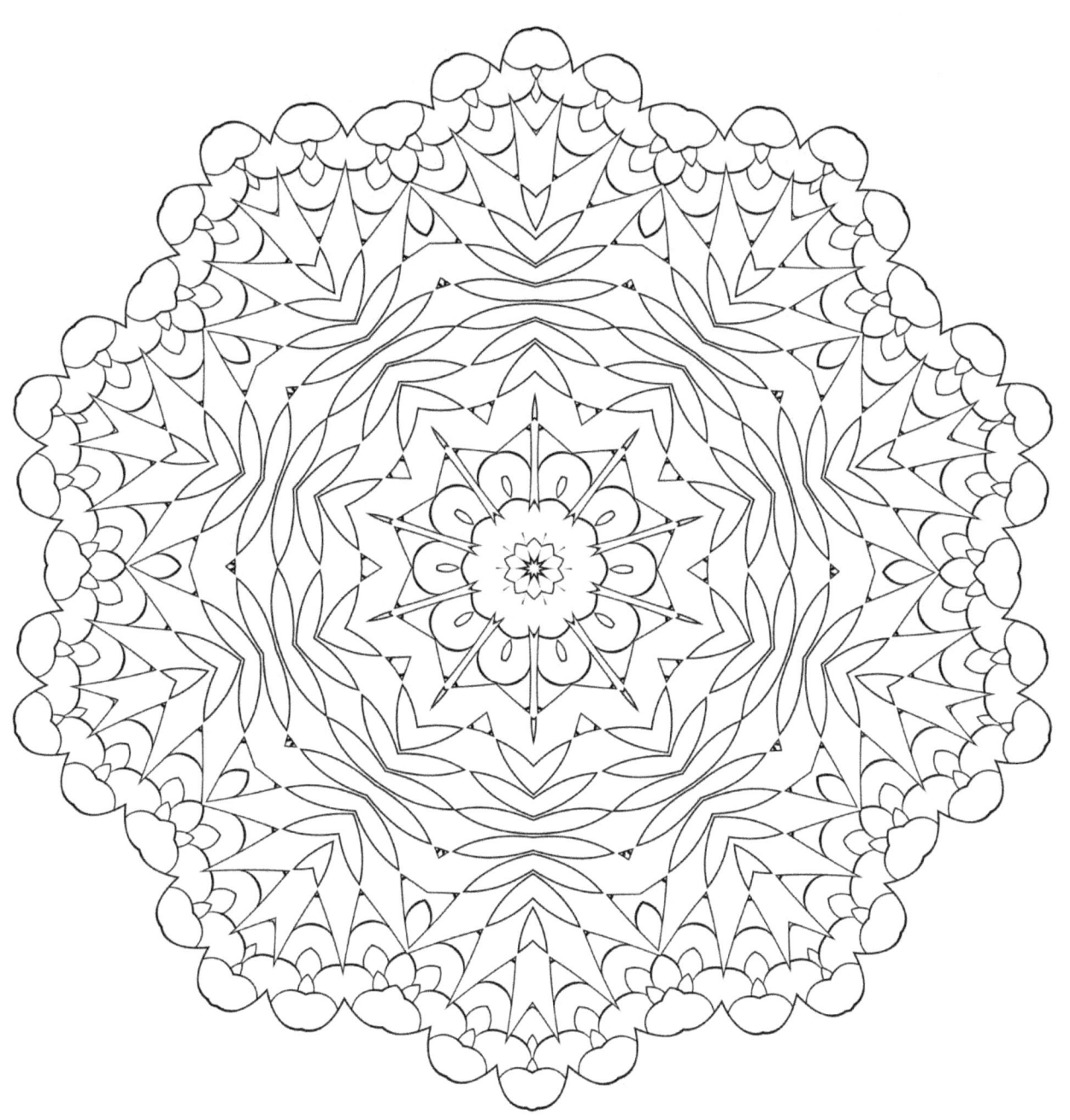

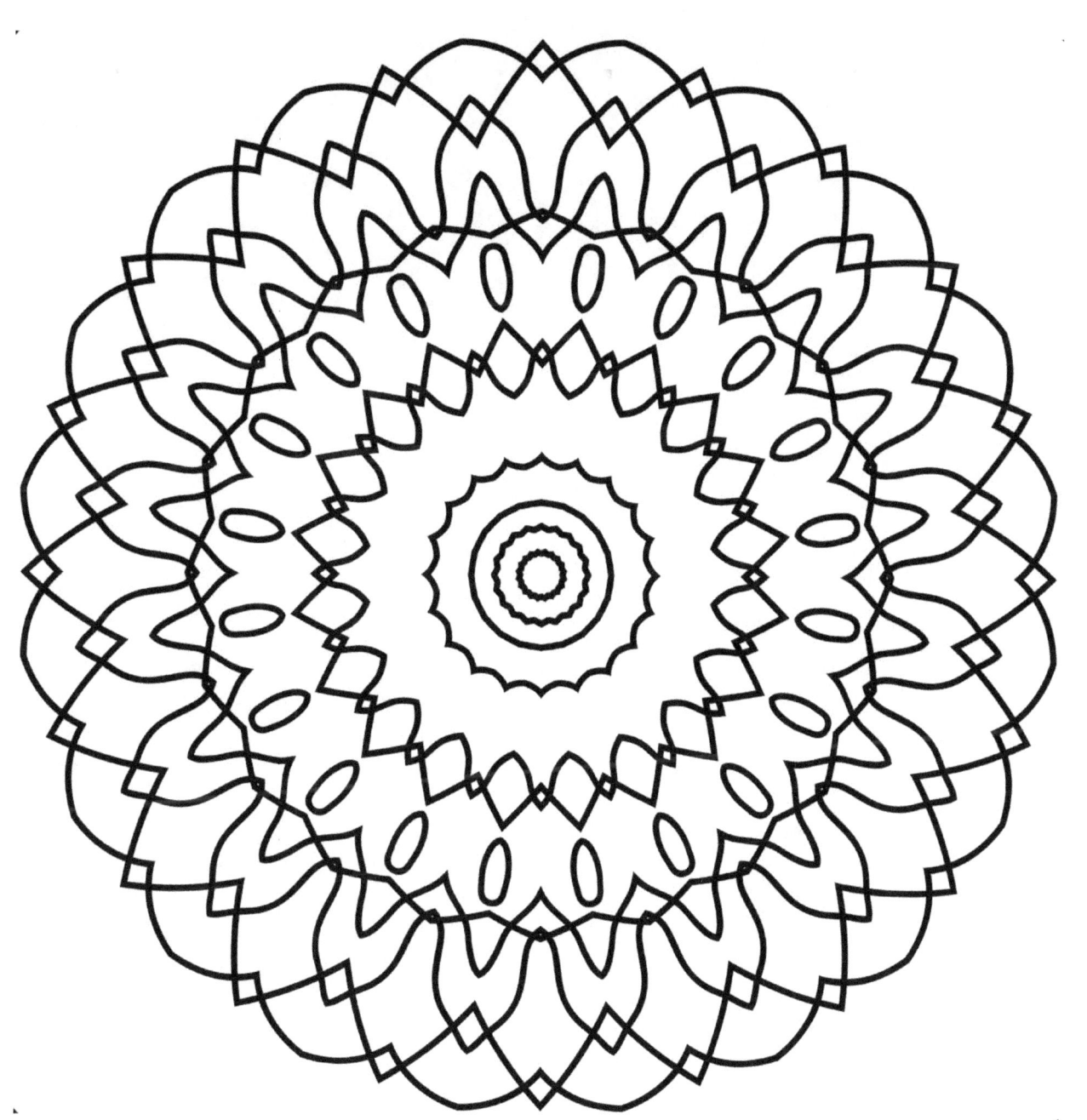

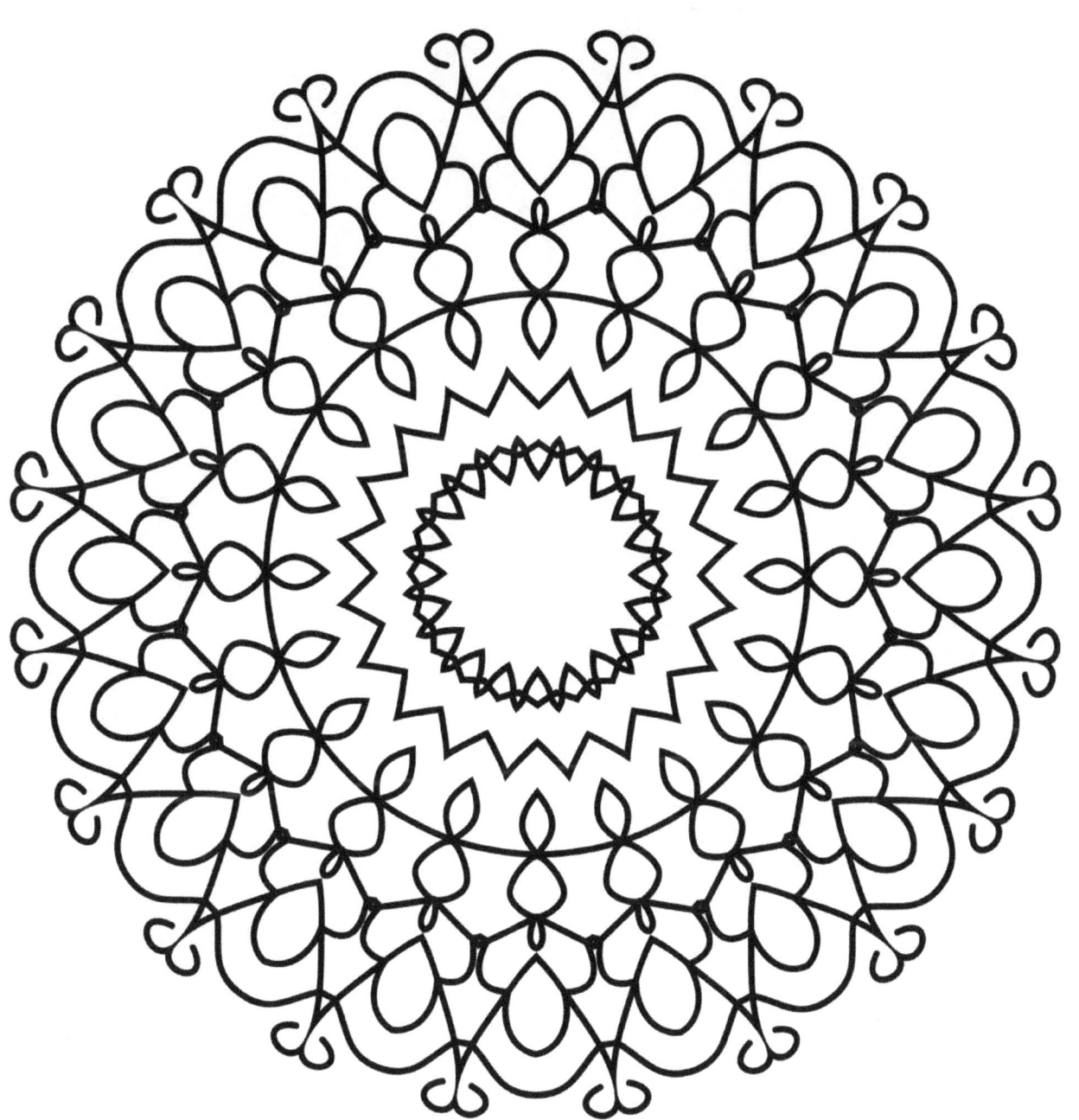

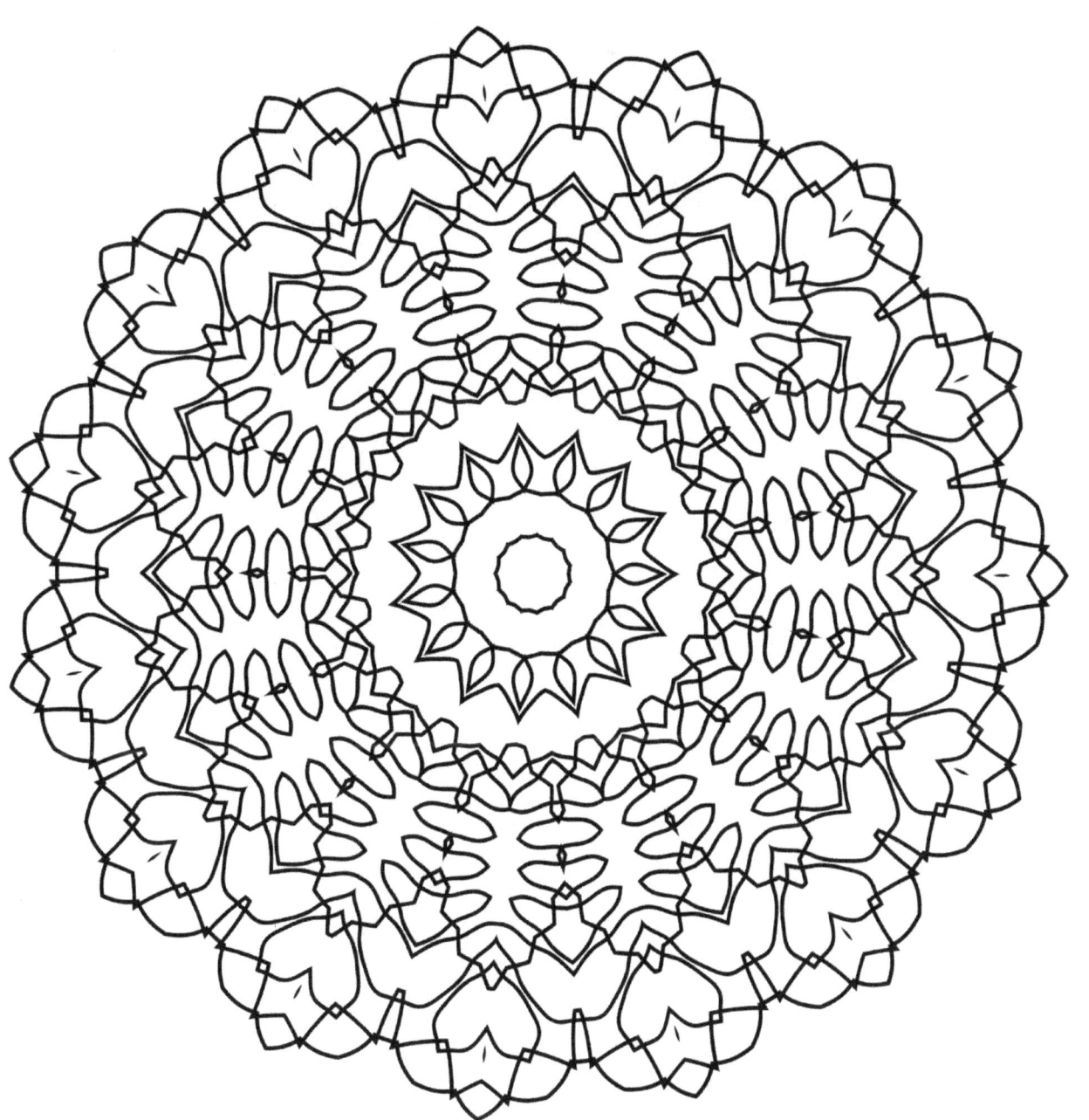

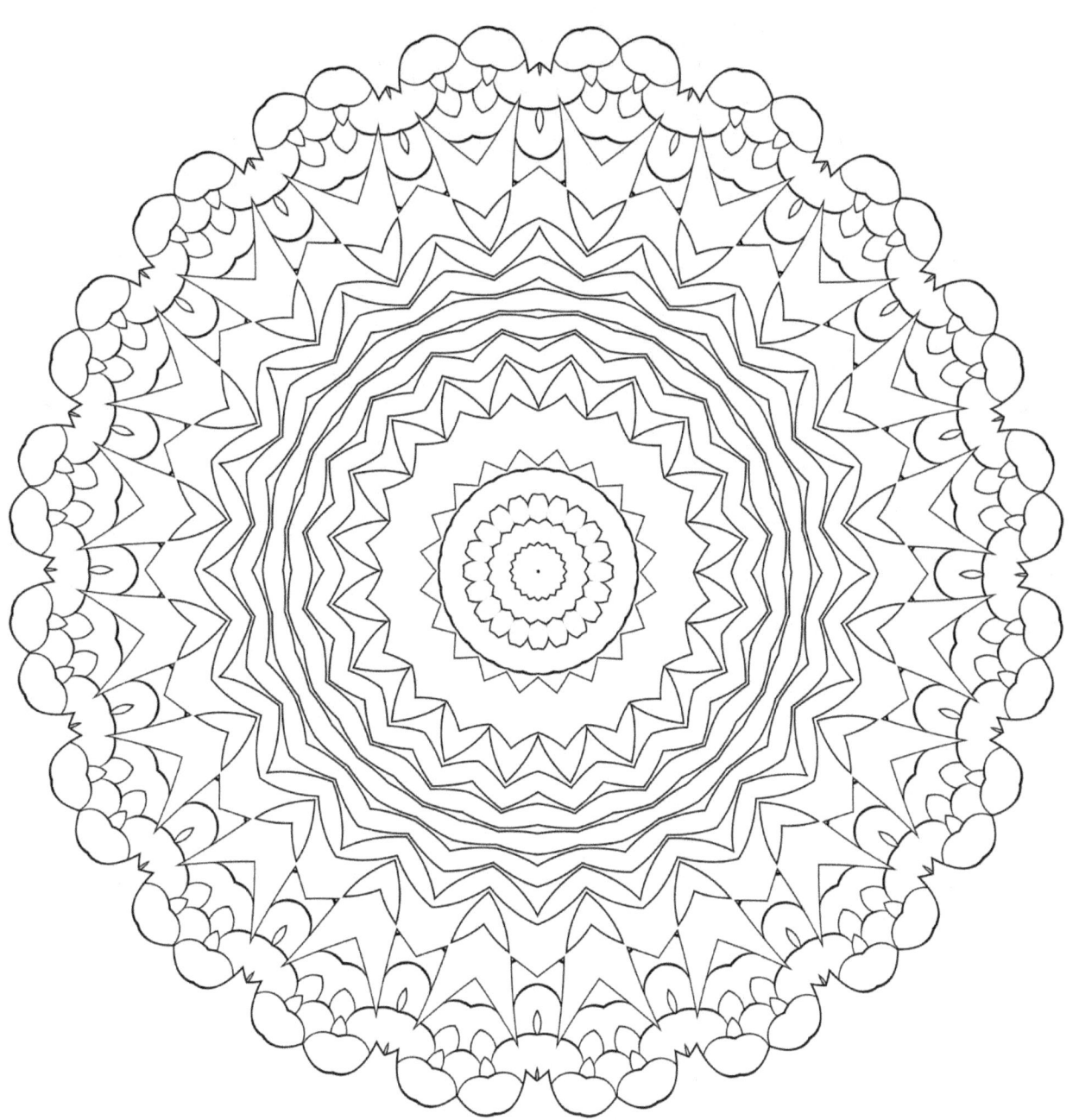